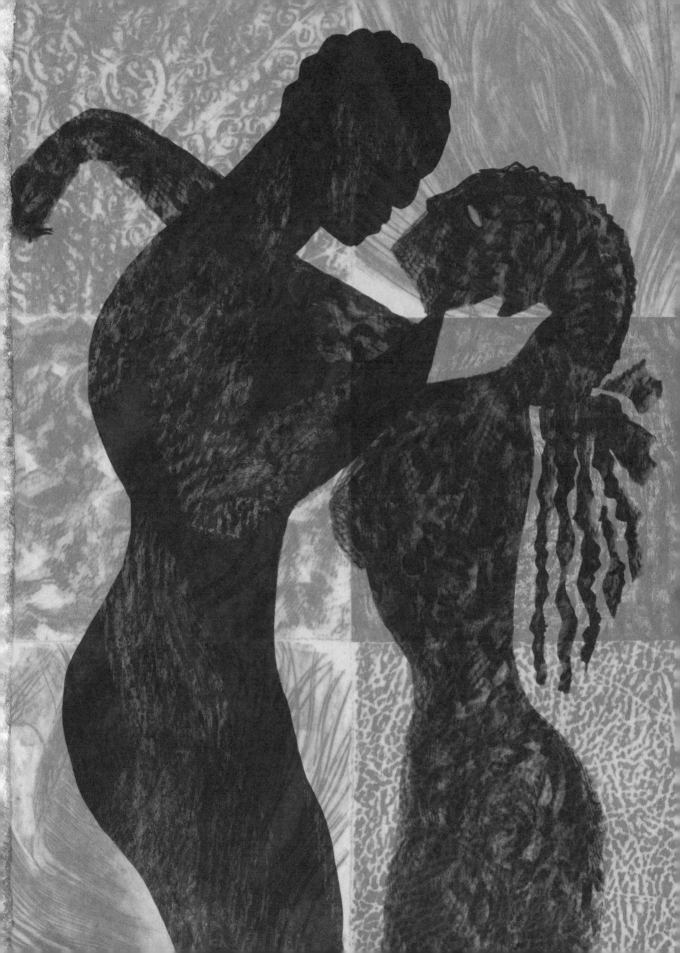

This book is dedicated to
my mother Norma Hall Cummings
—for her love
and my family Sean, Don, Sharece,
Chelsea, Kaitlyn, Doneen, Marjeth, Eilleen,
Melisa & Brenda Long
—for their support

Terrance Cummings

Too Hot
TO COOL DOWN

Stewart *Tabori* *&* **Chang**

let him put you down if he dares

I'll pick you up for myself,

just as soon, I don't care,

you'll never rest on a shelf.

"Put 'em Down Blues"

Eloise Bennett

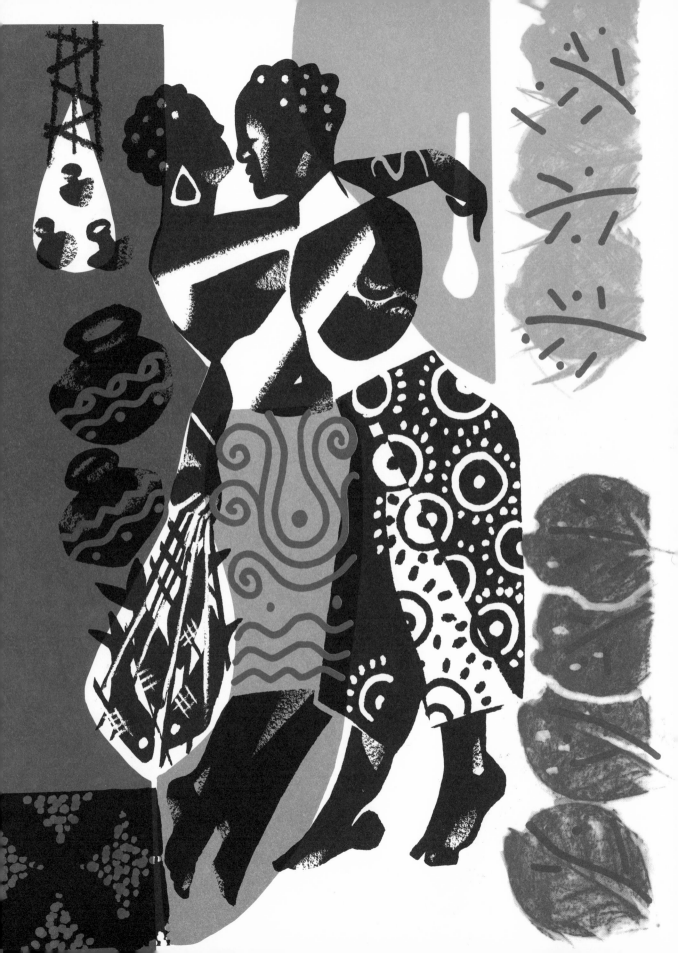

I've heard it said
that the thrill of romance
can be like a heavenly dream . . .
I go to bed with a prayer
that you'll make love to me.

"*L*over Man (Oh, Where Can You Be)"
Jimmy Sherman,
Roger "Ram" Ramirez,
and James Davis

*A*nother bride, another June

*A*nother sunny honeymoon,

*A*nother season, another reason

*F*or mak-in' whoopee!

"*M*ak-in' Whoopee!"
Gus Kahn

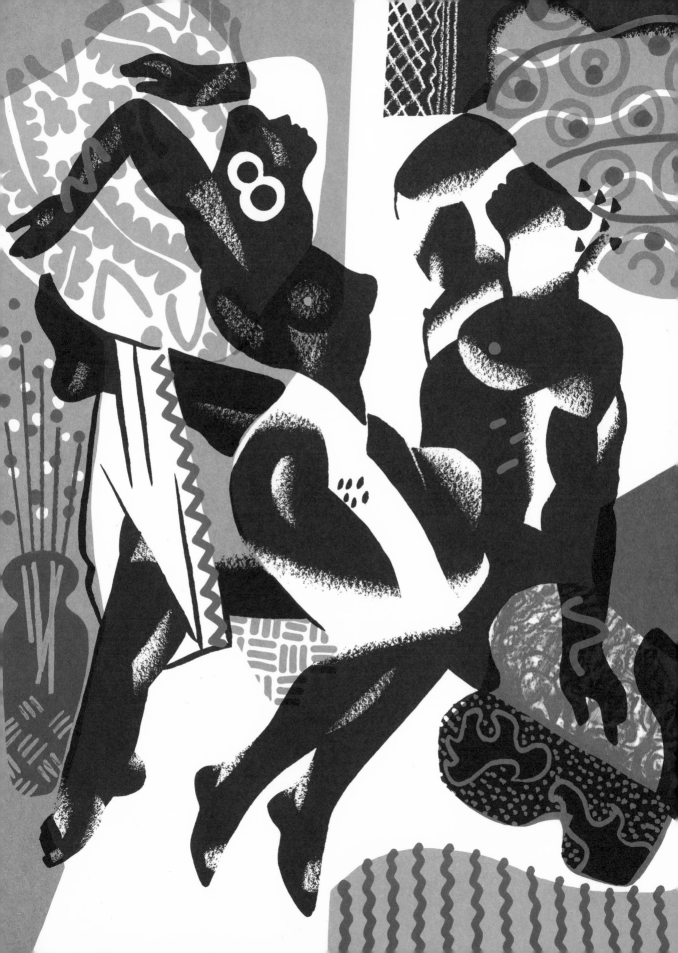

I'm lonely the whole day through,

Each night I pray that with the sunrise,

I'll find I'm looking into your eyes,

Come out of my dreams,

come into my arms . . .

"I'm So in Love with You"

Duke Ellington
and Irving Mills

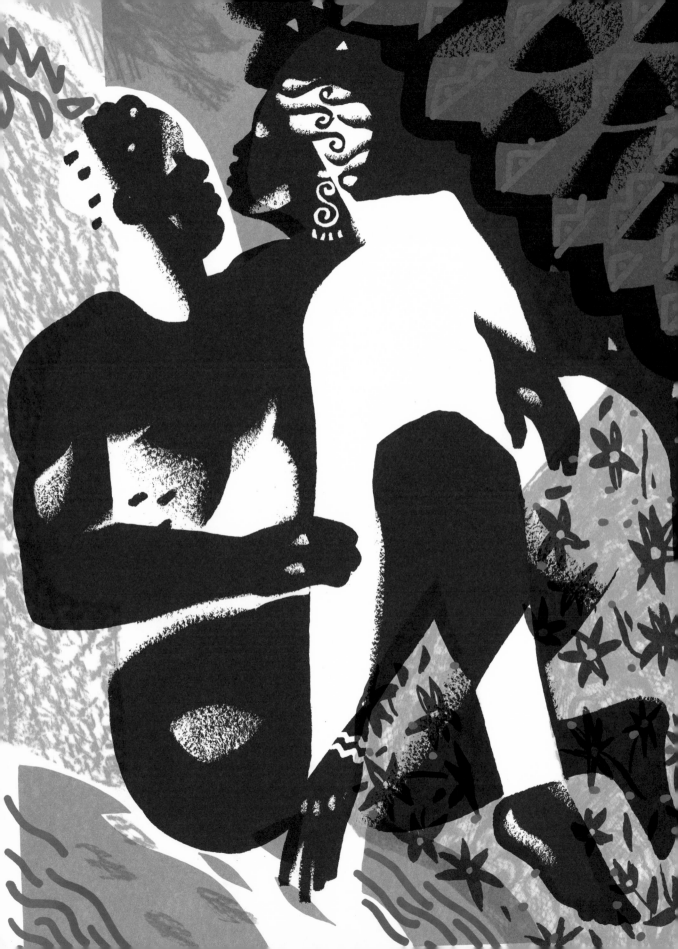

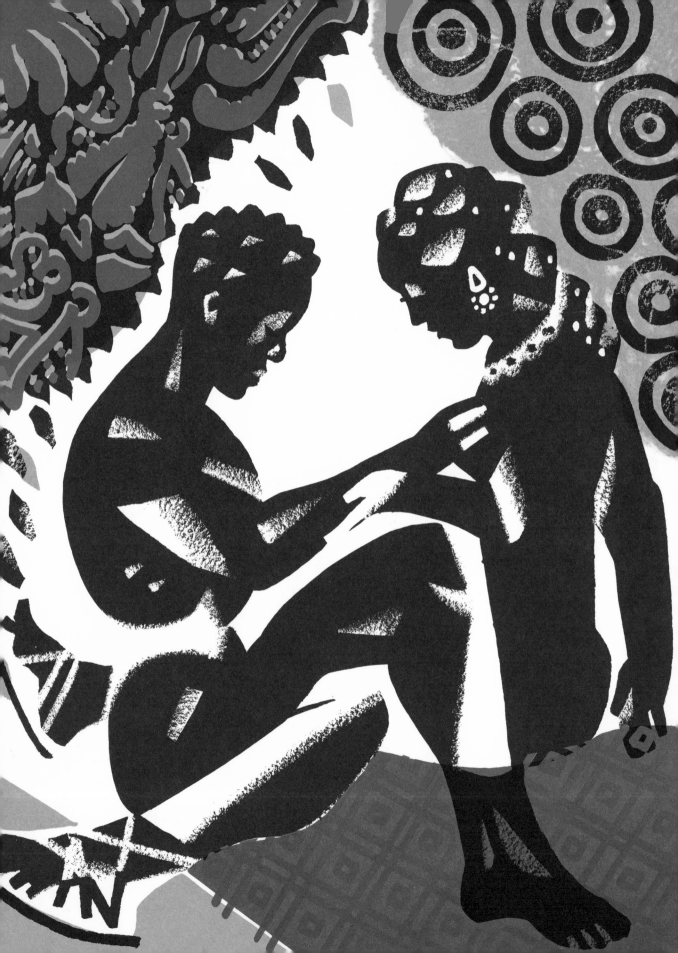

Since this is the perfect spot to learn,
Teach me tonight.

Starting with the *A, B, C,* of it,

Right down to the *X, Y, Z,* of it,

Help me solve the mystery of it,
Teach me tonight.

"Teach Me Tonight"
Sammy Cahn and Gene De Paul

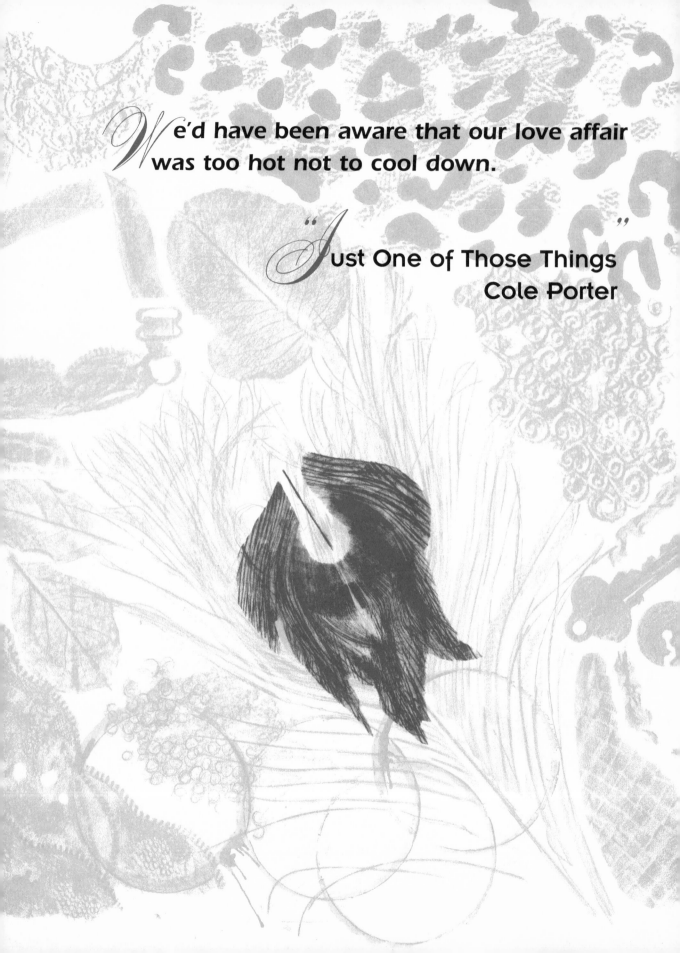

We'd have been aware that our love affair
was too hot not to cool down.

"Just One of Those Things"
Cole Porter

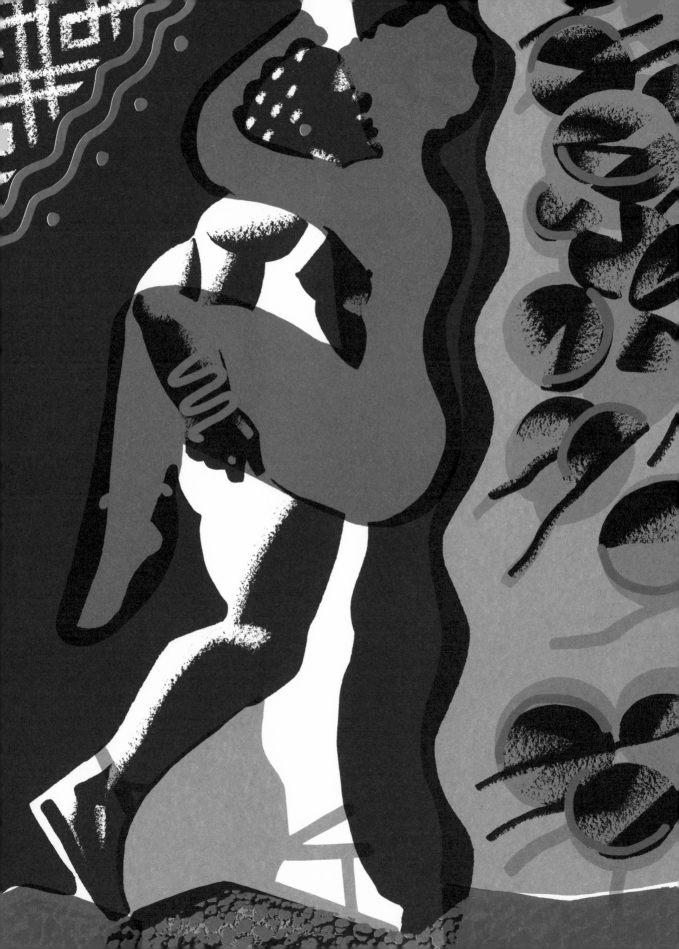

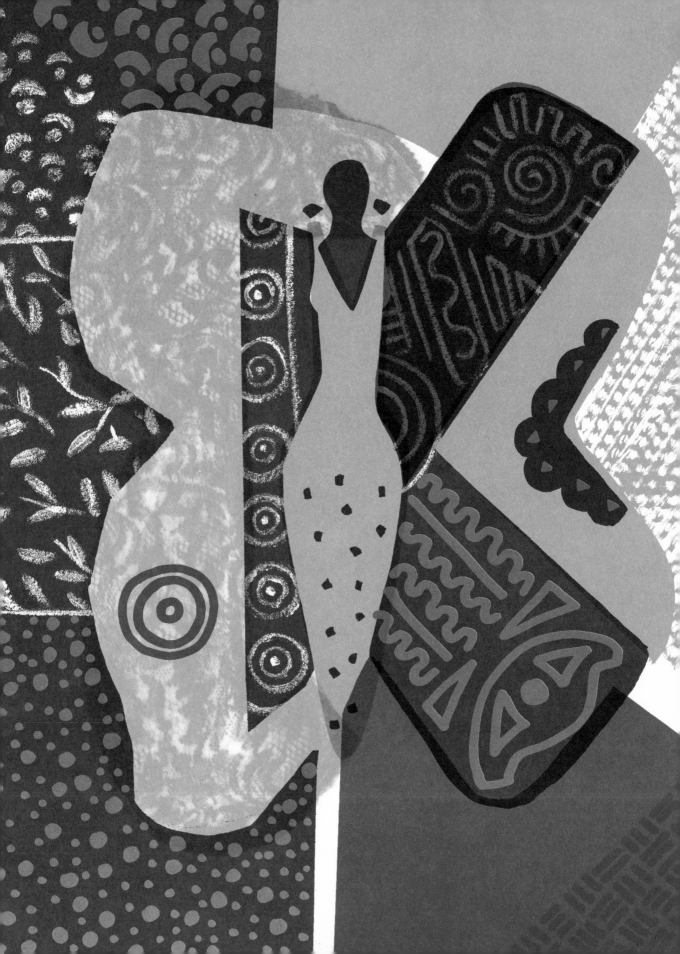

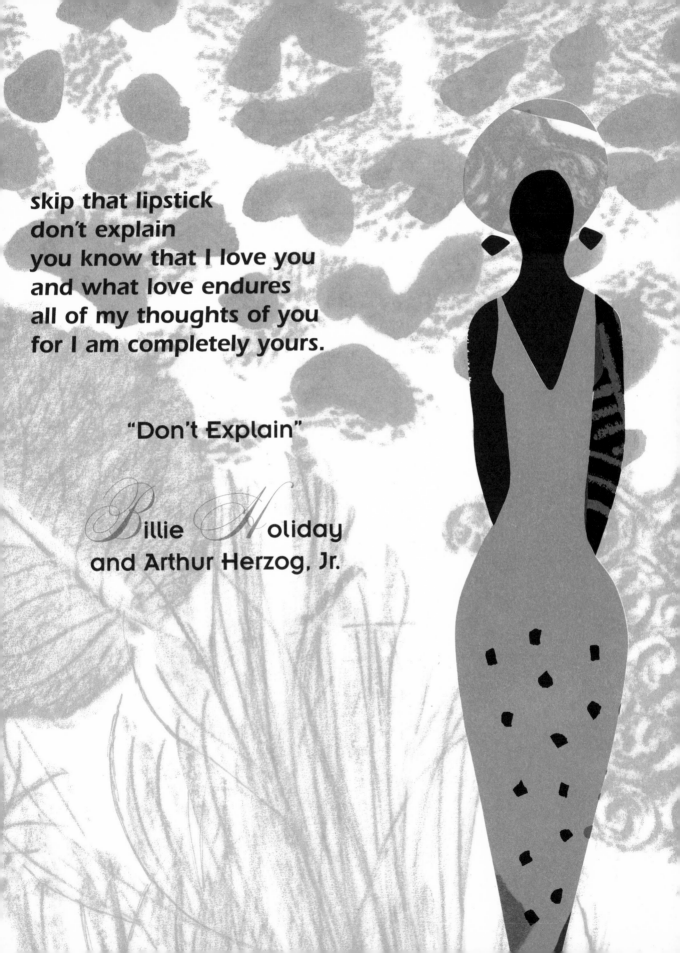

skip that lipstick
don't explain
you know that I love you
and what love endures
all of my thoughts of you
for I am completely yours.

"Don't Explain"

Billie Holiday
and Arthur Herzog, Jr.

My, how I miss your tender kiss
and the wonderful things you would do.
I run my hands thru' silv'ry strands
'cause I'm blue, turning gray over you . . .

"Blue Turning Gray Over You"
Andy Razaf and Fats Waller

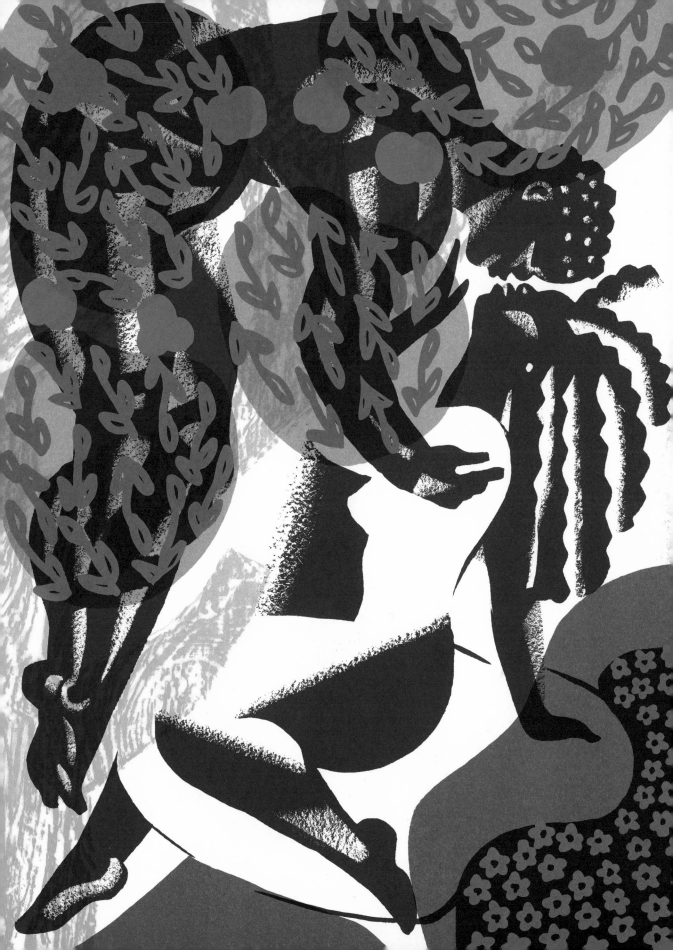

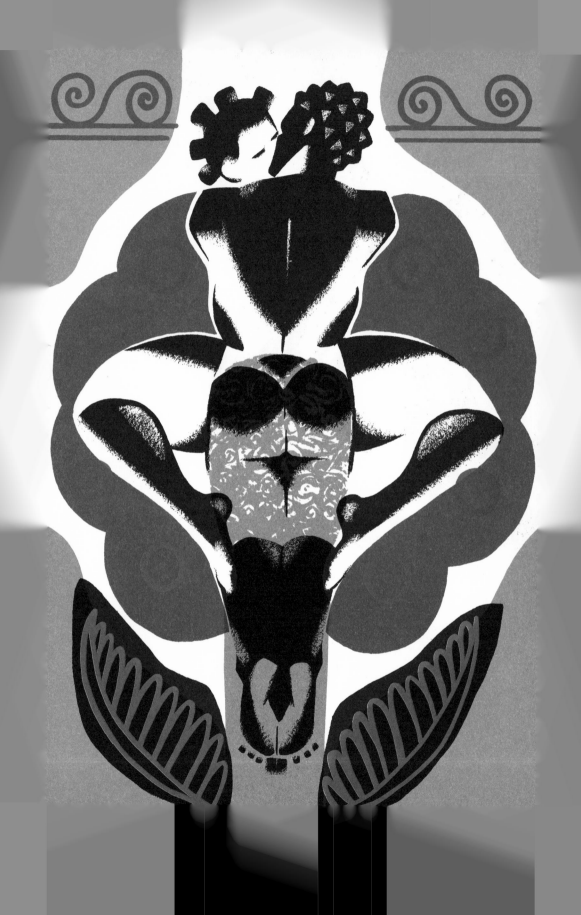

On the wings of every kiss drifts
a melody so strange and sweet
in this sentimental bliss
you make my paradise complete

"In a Sentimental Mood"

Duke Ellington,
Irving Mills, and
Manny Kurtz

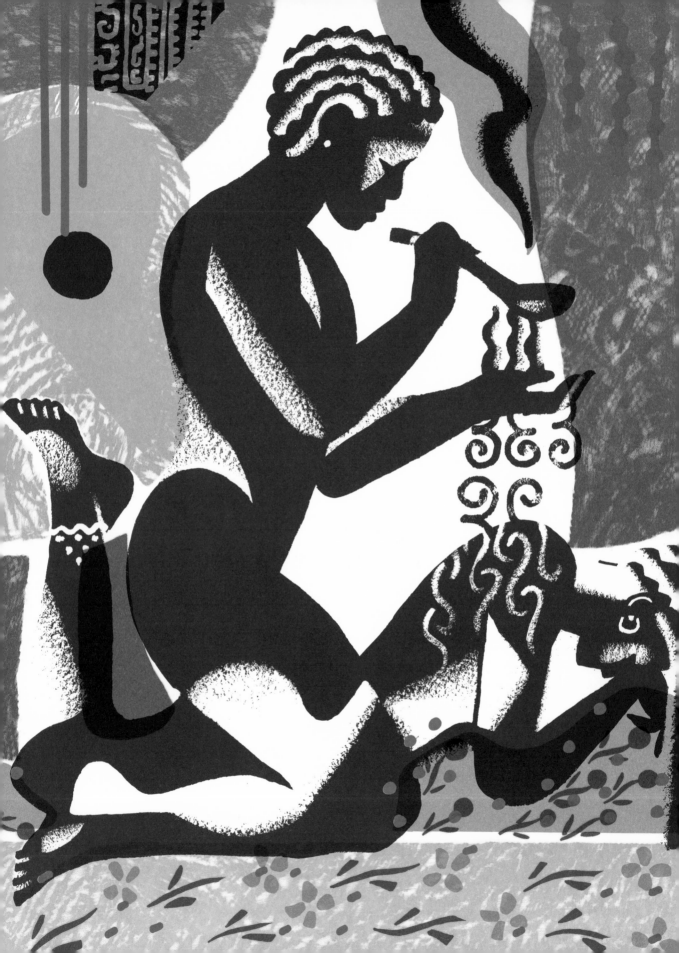

It could be a spoonful of diamonds,
Could be a spoon of gold.
Just a little spoonful of your precious love
satisfies my soul.

"*Spoonful*"
Willie Dixon

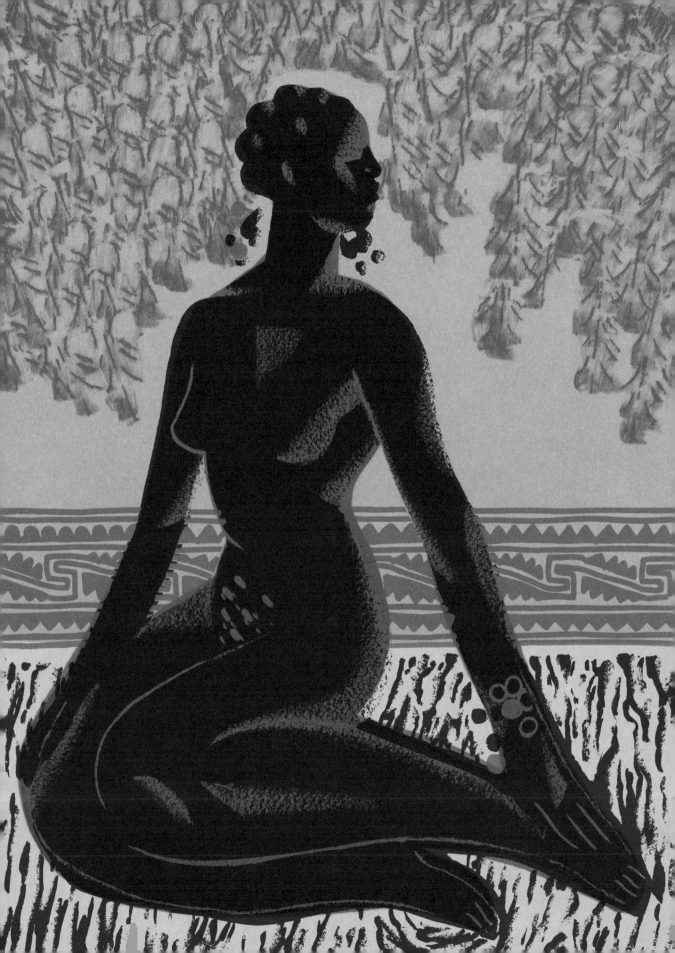

I know for certain the one I love,
I'm thru with flirtin',
Just you I'm thinkin' of,
Ain't misbehavin'
I'm savin' my love for you.

"Ain't Misbehavin'"
Andy Razaf.

Wait a while, till a little moonbeam comes
peeping through,
You'll get bold,
you can't resist her,
And all you'll say
when you have kissed her is

ooh,

What a little moonlight can do.

"What a Little Moonlight Can Do"

Harry Woods

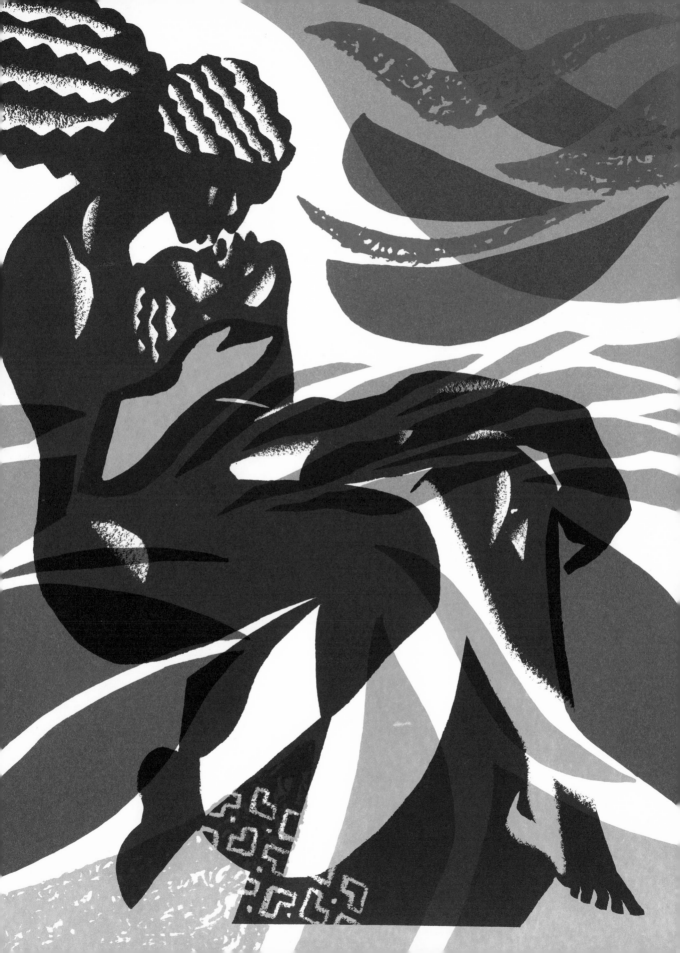

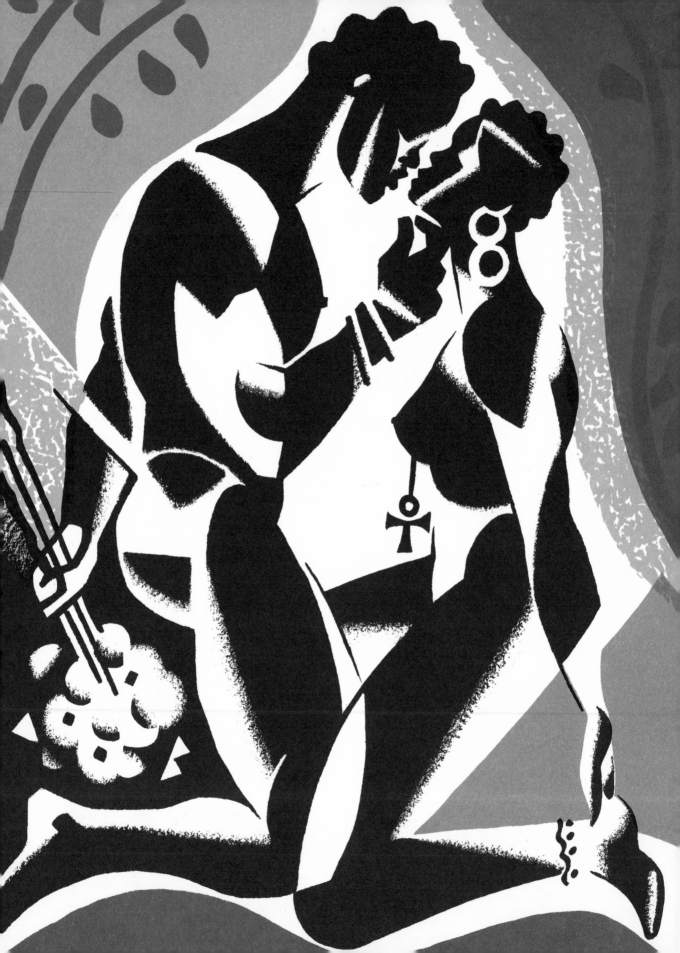

I need but you, 'cause you're my man,
You love me like no one can;
Something 'bout you I can't resist;
When you kiss me, daddy, I stay kissed.

"SQUEEZE ME"

Fats Waller
and
Clarence Williams

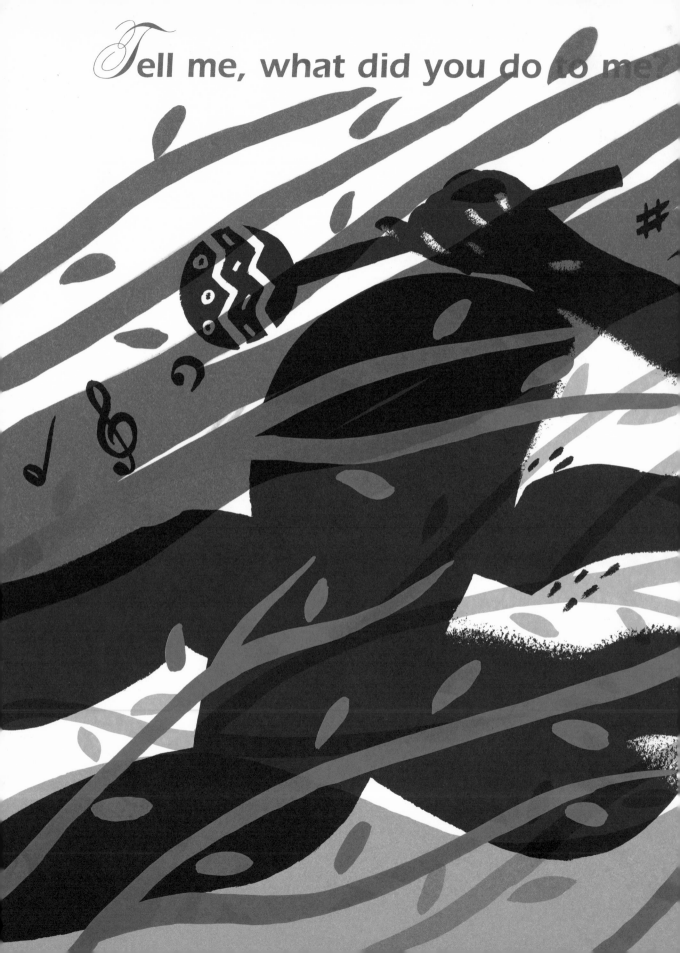

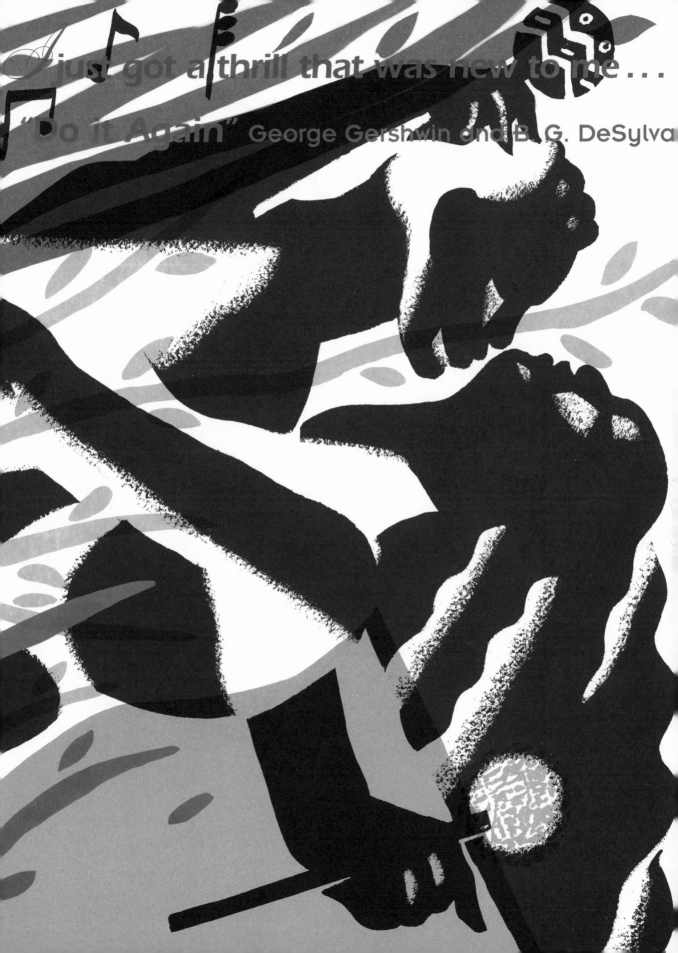

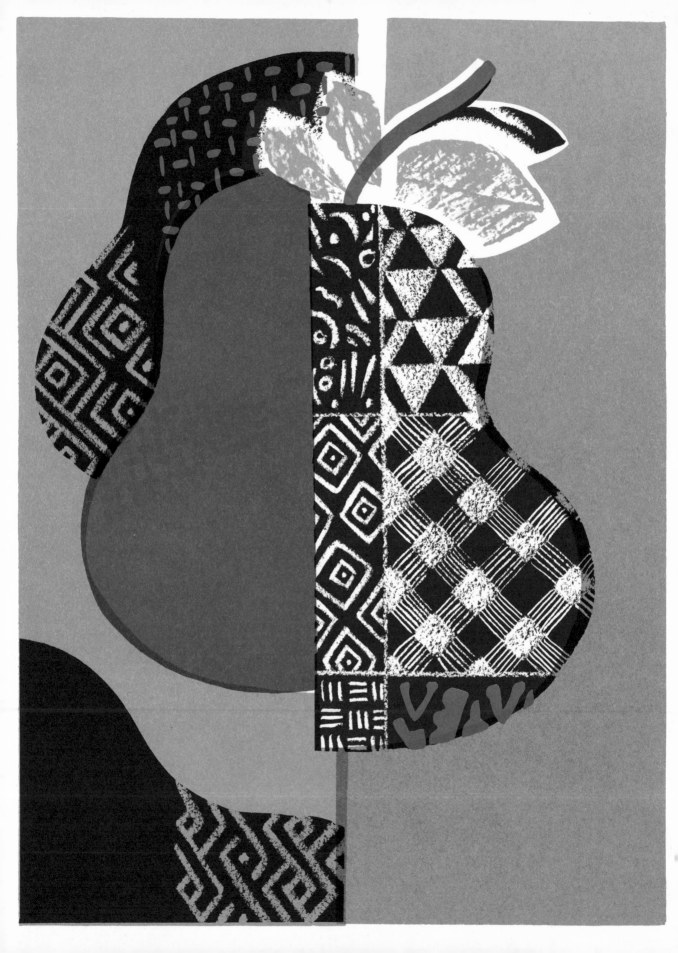

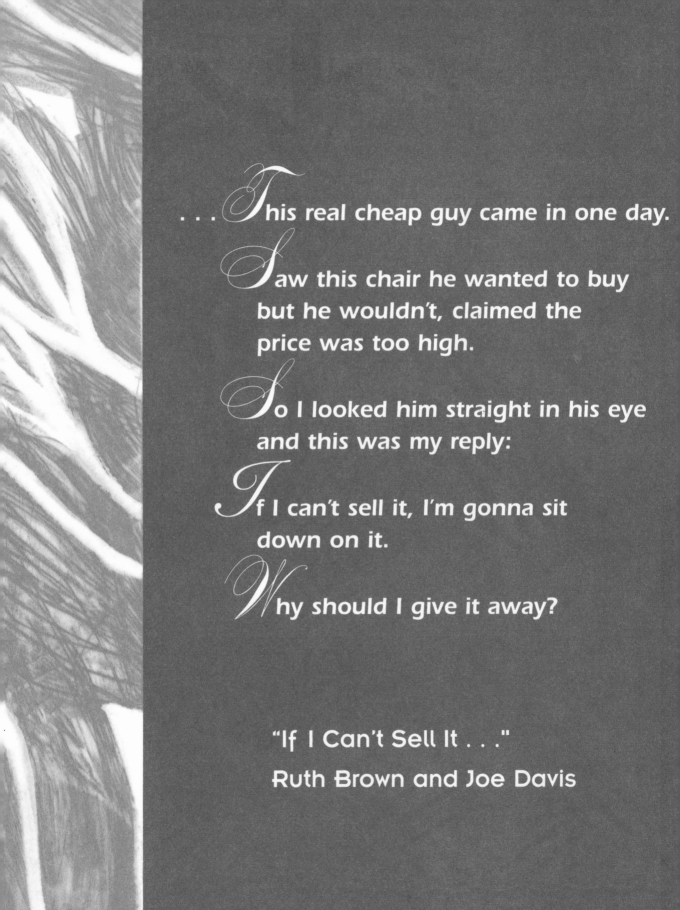

. . . This real cheap guy came in one day.

Saw this chair he wanted to buy
but he wouldn't, claimed the
price was too high.

So I looked him straight in his eye
and this was my reply:

If I can't sell it, I'm gonna sit
down on it.

Why should I give it away?

"If I Can't Sell It"
Ruth Brown and Joe Davis

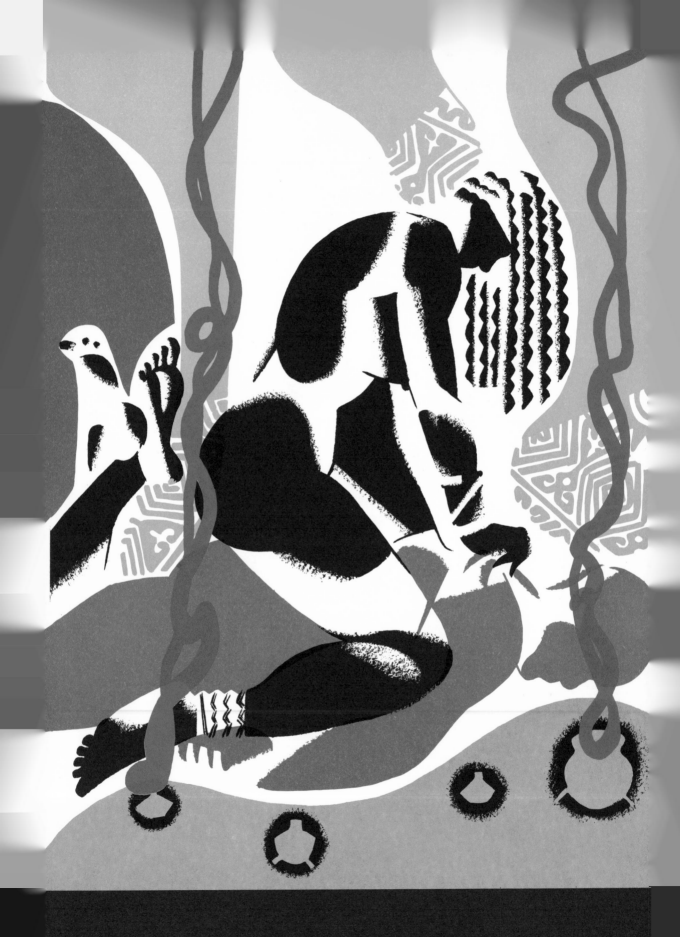

*A*ll I want to do is bake your bread
Just to make sure that you're well fed,
I don't want you sad and blue
I just want to make love to you . . .

"I Just Want to Make Love to You"
Willie Dixon

I'm keeping out of *mischief* now
really am in *love* and how
I'm through playing with *fire*
it is you I *desire*.

"Keeping Out of Mischief Now"
Con Conrad,
Andy Razaf, and
Fats Waller

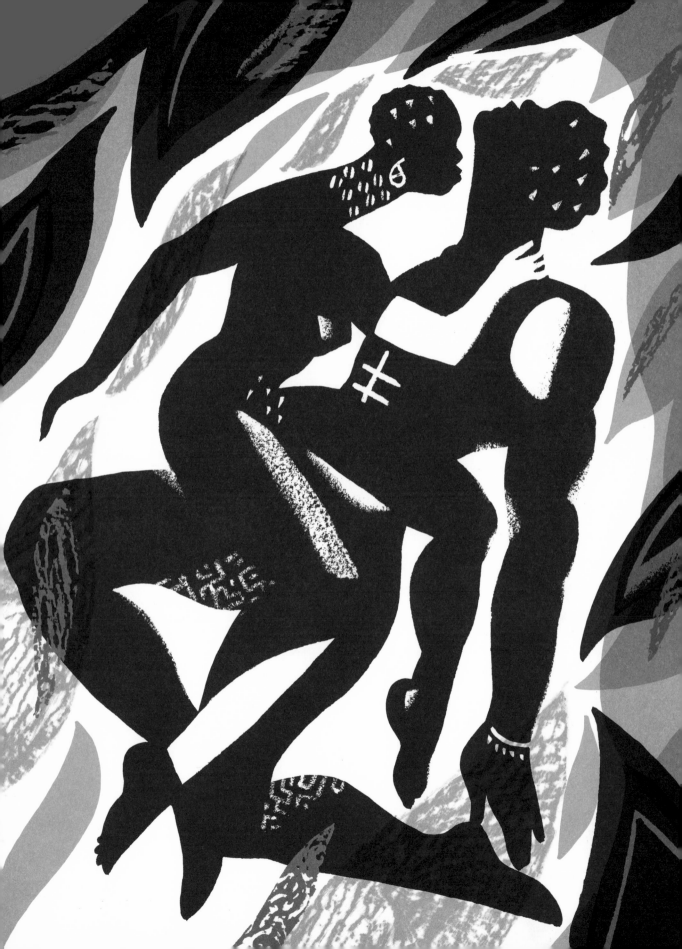

*U*nder the hide of me,

*T*here's an oh, such a hungry yearning
burning inside of me.

*A*nd its torment won't be through

*T*ill you let me spend my life
making love to you,

day and night
night and day.

"*N*ight and *D*ay"
Cole Porter

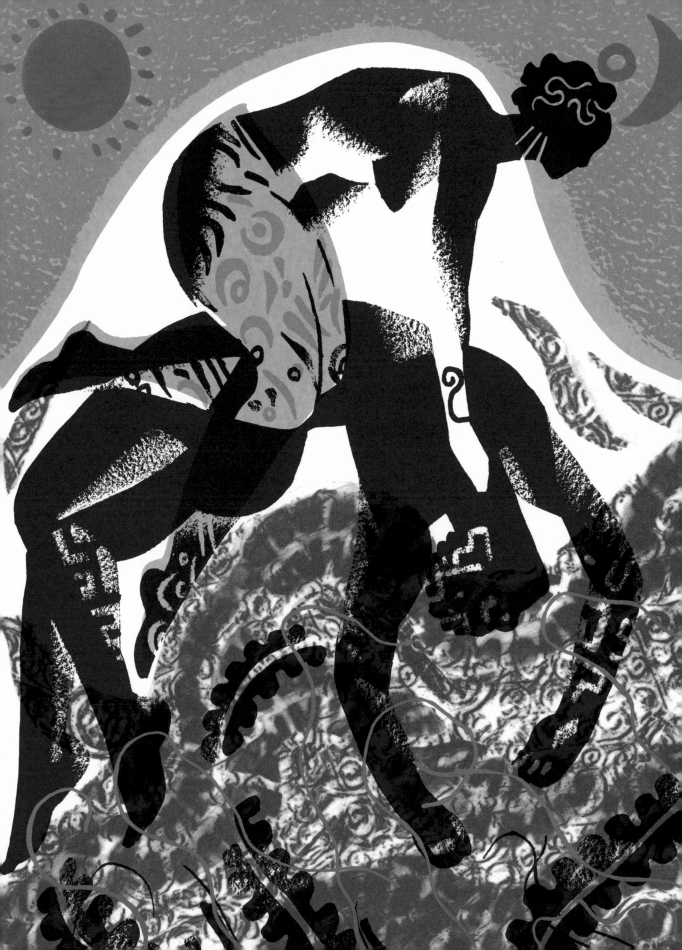

*L*ove is like a faucet

It turns off and on.

Sometimes when you think it's on, baby,

It has turned off and gone.

"Fine and Mellow"

Billie Holiday

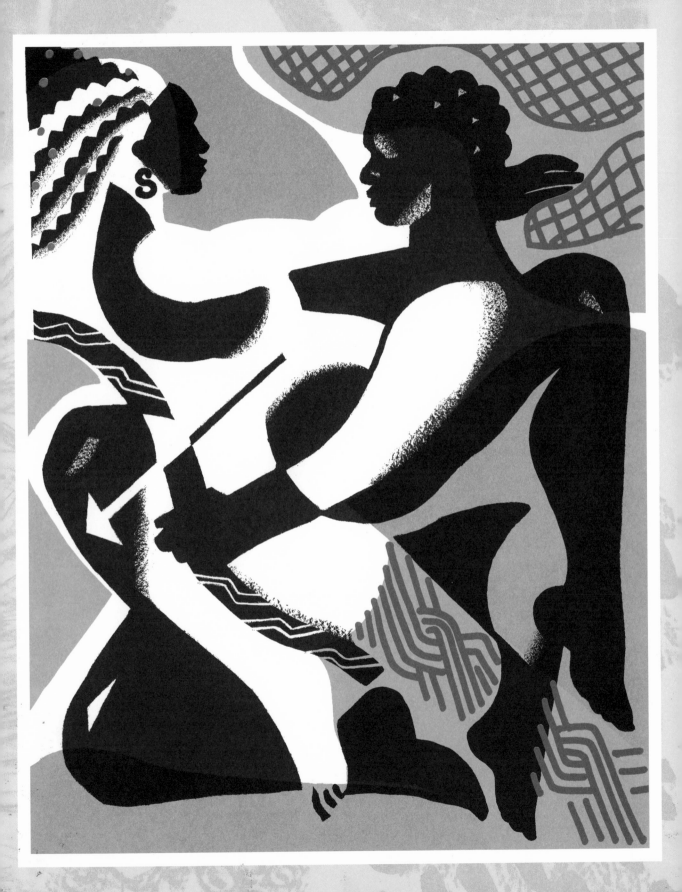

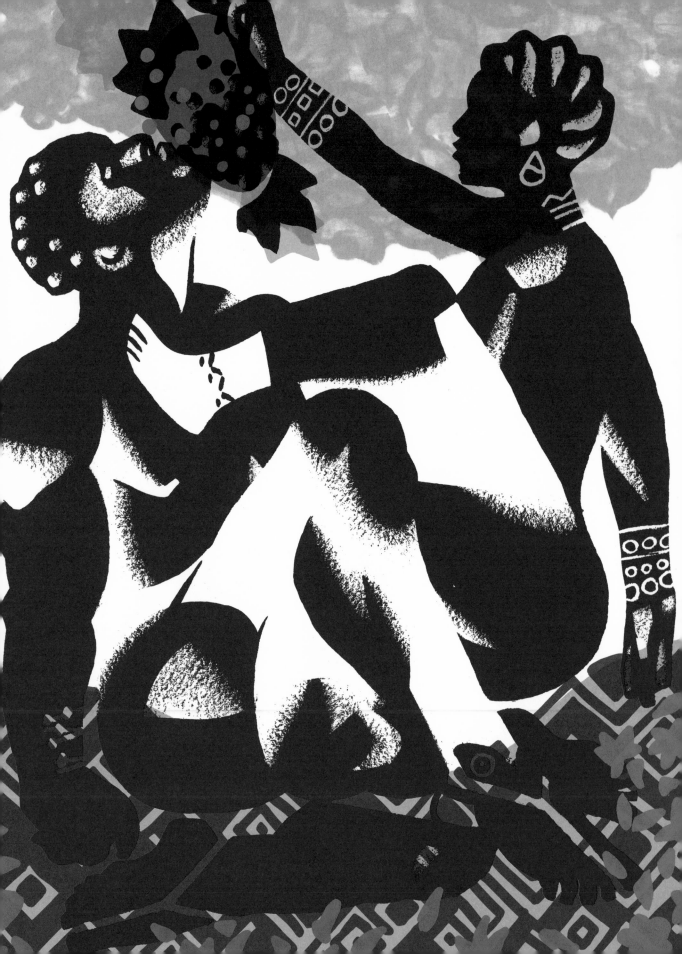

I taught her everything she knows,

and then what did she do?

*S*he turned to someone else

and taught him everything she knew!

"I
Taught Her
Everything She
Knows"

Arthur Kent and Sylvia Dee

*T*ell me, why should it be

*Y*ou have the power to hypnotize me

*L*et me live 'neath your spell,

*D*o do that voodoo that you do so well . . .

"You Do Something To Me"
Cole Porter

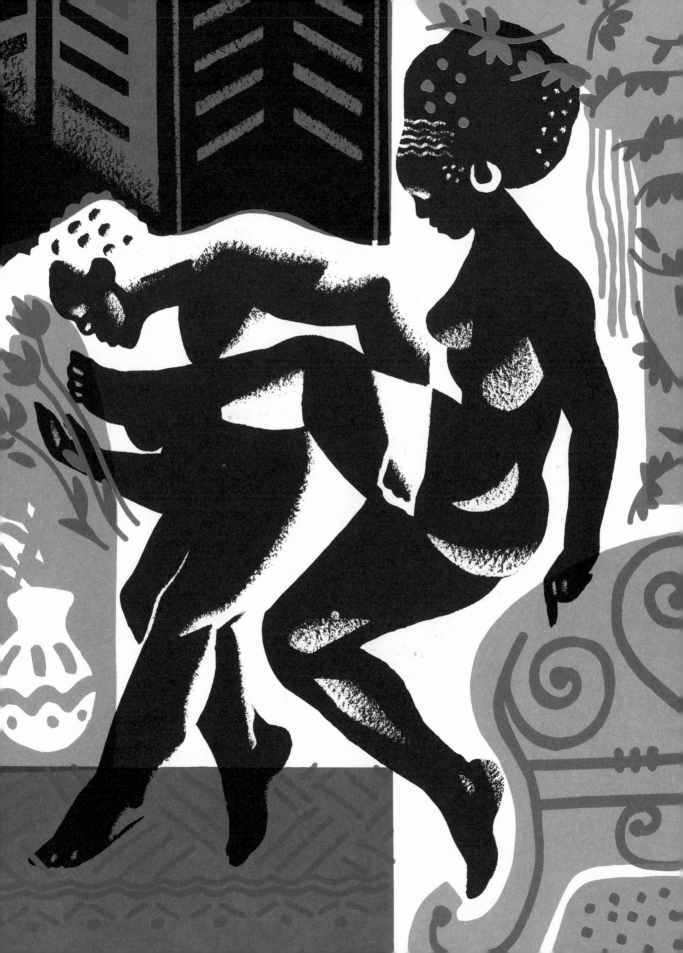

If you hear a song in blue

like a flower crying for the dew

That was my *heart* serenading you

My prelude to a kiss . . .

"Prelude To a Kiss"

Duke Ellington,
Irving Mills, and
Irving Gordon

ACKNOWLEDGMENTS

Thank you, God, and the following organizations and music companies for their assistance in directing me with my research: The Schomberg Library and Research Center, Lincoln Center Music Archives, Warner Bros. Publications, MCA Music Publishing, Bug Music Inc., The Songwriters Guild of America, ASCAP, BMI, SESAC, Music Sales Corp., Redwood Music Ltd, Carlin America Inc., and Billboard Magazine.

Thanks also to Susan Berkowitz, Sid Edwards, Jeff and Lisa Barr and Chris Stys of Mod Graphics, Ken Strand, Susan Capriano, Jean Montiel, Bobby Johnson, Edward Proffitt, Zaraya Mendez, James Morton, Lucille Davis Bell, James Briggs Murray, Sonia Gomes, Thomas Casey, Winifred Dawson, Vita, Bruce, Ed Benson and the 'Q' Club: Bill, Cian, & Alvina. And to Lena Tabori for believing, Nai Chang for designing, Linda Sunshine for editing, Christopher Young and Alice Wong for production, and Wayne Palma for research.

A special thank you to E. Ethelbert Miller, Rosemarie Gawelko, and Kate Scott Douglas for helping make this book possible.

Published in 1996 and distributed in the U.S. by Stewart, Tabori & Chang,
a division of U.S. Media Holdings, Inc.
575 Broadway
New York, N.Y. 10012

Distributed in Canada by
General Publishing Company Ltd.
30 Lesmill Road
Don Mills, Ontario, M3B 2T6 Canada
Distributed in all other territories by
Grantham Book Services Ltd.
Issac Newton Way, Alma Park Industrial Estate
Grantham, Lincolnshire, NG31 9SD England
Sold in Australia and New Zealand by
Peribo Pty Ltd.
58 Beaumont Road
Mount Kuring-gai, NSW 2080, Australia

ISBN: 1-55670-510-7

Library of Congress Card Catalog Number:
96-69436

Printed in the United States

10 9 8 7 6 5 4 3 2 1

PERMISSIONS

"Ain't Misbehavin'" Music by Thomas "Fats" Waller and Harry Brooks, words by Andy Razaf ©1929 (Renewed) EMI Mills Music Inc., Chappell & Co., and Razaf Music in USA. All rights outside USA administered by EMI Mills Music, Inc. and Chappell & Co. All rights reserved. Used by permission. Warner Bros. Publications U.S. Inc., Miami, Florida 33014.

"Blue Turning Gray Over You" by Andy Razaf and Thomas "Fats" Waller ©1929, 1930 (Copyrights renewed) Chappell & Co. (ASCAP) and Edwin H. Morris & Co. (ASCAP). All rights administered by Chappell & Co. All rights reserved. Used by permission. Warner Bros. Publications U.S. Inc., Miami, Florida 33014.

"Do It Again" by George Gershwin and B. G. DeSylva ©1992 (Renewed) WB Music Corp., New World Music Company Ltd., and Stephen Ballentine Music. All rights reserved. Used by permission. Warner Bros. Publications U.S. Inc., Miami, Florida 33014.

"Don't Explain" Words and music by Billie Holiday and Arthur Herzog, Jr. Copyright ©1946 Duchess Music Corporation. Duchess Music Corporation is an MCA company. All rights reserved. Used by permission. Copyright renewed. International copyright secured.

"Fine and Mellow" by Billie Holiday ©1939 Edward B. Marks Music Company. Copyright renewed. Used by permission. All rights reserved.

"I Just Want To Make Love To You" Written by Willie Dixon ©1959, 1987 Hoochie Coochie Music (BMI). Administered by Bug Music. All rights reserved. Used by permission.

"I Taught Her Everything She Knows" by Arthur Kent and Sylvia Dee. Copyright ©1966 by (Renewed) by Music Sales Corporation c/o Arthur Kent Music Co. and Ed Proffitt Music. International copyright secured. All rights reserved. Reprinted by permission.

"I'm So In Love With You" by Duke Ellington and Irving Mills ©1930 (Renewed) EMI Mills Music, Inc., and Famous Music Corporation in USA.

All rights outside USA controlled by EMI Mills Music, Inc. All rights reserved. Used by permission. Warner Bros. Publications U.S. Inc., Miami, Florida 33014.

"If I Can't Sell It . . ." by Ruth Brown and Joe Davis. Joe Davis Music. Used by permission.

"In a Sentimental Mood" by Duke Ellington, Irving Mills, and Manny Kurtz ©1935 (Renewed) EMI Mills Music, Inc. and Famous Music Corporation in USA. All rights outside USA controlled by EMI Mills Music, Inc. All rights reserved. Used by permission. Warner Bros. Publications U.S. Inc., Miami, Fla 33014.

"Just One of Those Things" Words and music by Cole Porter ©1935 (Renewed) Warner Bros. Inc. All rights reserved. Used by permission. Warner Bros. Publications U.S. Inc., Miami, Florida 33014.

"Keepin' Out of Mischief" by Con Conrad, Andy Razaf, and Thomas "Fats" Waller ©1932 (Renewed) Chappell & Co., Con Conrad Music Publ., Anne Rachel Music Co., Edwin H. Morris Co. All rights reserved. Used by permission. Warner Bros. Publications U.S. Inc., Miami, Florida 33014.

"Lover Man (Oh, Where Can You Be)" Words and music by Jimmy Sherman, Roger "Ram" Ramirez, and James Davis ©1941, 1942 MCA Music Publishing, a division of MCA, Inc. All rights reserved. Used by permission. Copyright renewed. International copyright secured.

"Makin' Whoopee" Lyrics by Gus Kahn, music by Walter Donaldson ©1928 (Renewed) WB Music Corp. Rights for extended term in USA assigned to WB Music Corp., Gilbert Keyes Music, and Donaldson Publishing Corp. All rights reserved. Used by permission. Warner Bros. Publications U.S. Inc., Miami, Florida 33014.

"Night and Day" Words and music by Cole Porter ©1932 (Renewed) Warner Bros. Inc. All rights reserved. Used by permission. Warner Bros. Publications U.S. Inc., Miami, Florida 33014.

"Prelude to a Kiss" by Duke Ellington, Irving Mills, and Irving Gordon ©1938 (Renewed) EMI Mills Music, Inc. and Famous Music Corporation in USA. All rights outside USA controlled by EMI Mills Music, Inc. All rights reserved. Used by permission. Warner Bros. Publications U.S. Inc., Miami, Florida 33014.

"Put 'em Down Blues" Words and music by Eloise Bennett ©1928 MCA Music Publishing, a division of MCA, Inc. All rights reserved. Used by permission. Copyright renewed. International copyright secured.

"Spoonful" Written by Willie Dixon ©1960, 1988 Hoochie Coochie Music (BMI). Administered by Bug Music. All rights reserved. Used by permission.

"Squeeze Me" Words and music by Thomas "Fats" Waller and Clarence Williams. Copyright ©1925, 1957 MCA Music Publishing, a division of MCA, Inc. All rights reserved. Used by permission of Bienstock Publishing Company o/b/o Redwood Music Ltd. Copyright renewed. International copyright secured.

"Teach Me Tonight" by Sammy Cahn and Gene DePaul ©1953, 1954 The Hub Music Company © Renewed. Assigned to The Hub Music Company & Cahn Music Company. All Rights o/b/o Cahn Music Company administered by WB Music Corp. All rights reserved. Used by permission. Warner Bros. Publications U.S. Inc., Miami, Florida 33014.

"What a Little Moonlight Can Do" Words and music by Harry Woods ©1934 (Renewed) Cinephonic Music Co. Ltd. All rights in USA and Canada administered by Warner Bros. Inc. All rights reserved. Used by permission. Warner Bros. Publications U.S. Inc., Miami, Florida 33014.

"You Do Something to Me" Words and music by Cole Porter ©1929 (Renewed) Warner Bros. Inc. All rights reserved. Used by permission. Warner Bros. Publications U.S. Inc., Miami, Florida 33014.